D1303975

Maryland Landscapes

Kenneth Basile

Dedication

Introduction

I've lived most of my life in Maryland. My parents and I moved to the Prince Georges County suburbs in 1949. The United States was in the midst of demobilization after World War II and there were many new jobs in the federal government. Because of this, a demand for housing resulted in sprawling suburbs in the area. I was fortunate, in that I was given the opportunity to spend all of my childhood exploring the farms and forests that had not yet been developed at the edges of Washington, D. C. There was no Baltimore-Washington Parkway or Washington Beltway. These early experiences were the beginning of my appreciation for the Maryland landscape.

Our summer vacations were spent in Ocean City before the Chesapeake Bay Bridge was built. Steamboats still provided transportation around the Bay and the car ferry was a gateway to a different land for me. In the fall, we would travel to the mountains of Western Maryland to view the vibrant colors of the dense undeveloped forests.

After earning my driver's license, I continued exploring the state, always marveling at its diversity of landscape. During my time away from home in the military, I was stationed in the western United States. I found myself missing the greens and other intense colors and geographic subtleties of the Maryland landscape. As soon as I could, I returned to Maryland and was fortunate enough to be able to live on its Eastern Shore.

Then, in the early 1970s, this peninsula was relatively untouched by the housing and business sprawl that rapidly developed around the Baltimore-Washington, D.C. corridor. My fascination with the landscape continued, but included observations of the relationships that had developed between the built environment and the natural environment throughout the state. Given the opportunity to produce a photographic study, I decided to document this relationship. The following photographs are a reflection of my observations of the Maryland landscape as it exists today.

Ewell, Smith Island,
Somerset County

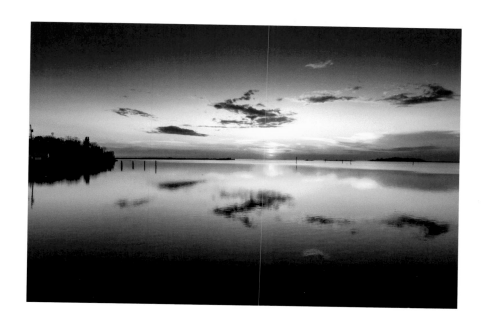

Fish Trap, Tangier Sound, Chesapeake Bay,
Wicomico County

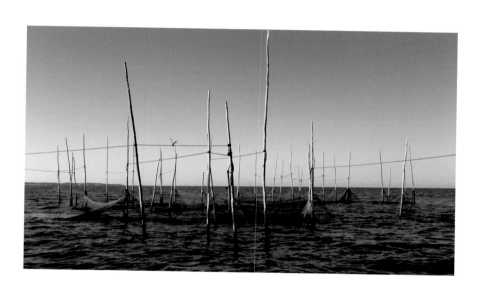

Nanticoke River, The Cove,
Bivalve, Wicomico County

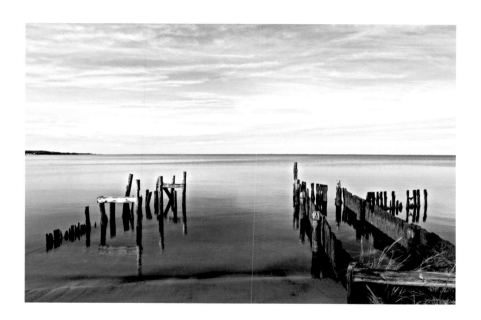

Work Boats, Rumbley,
Somerset County

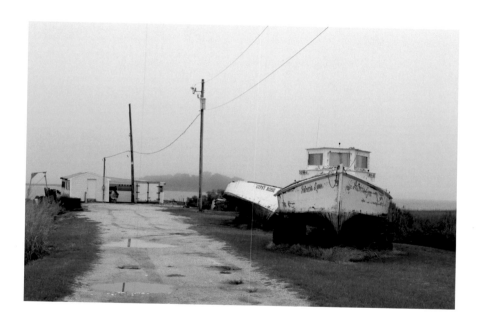

Blue House, Mad Calf Lane,
Nanticoke, Wicomico County

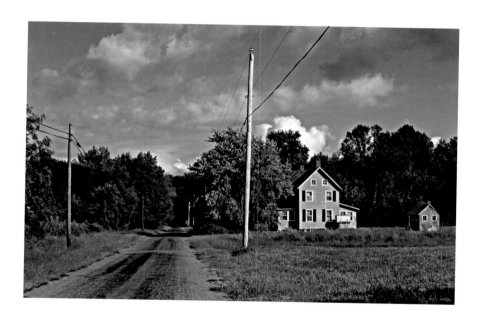

Bird Houses, Ewell, Smith Island,
Somerset County

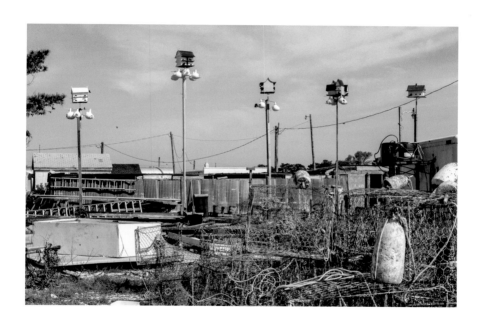

Spring Lane, Nanticoke,
Wicomico County

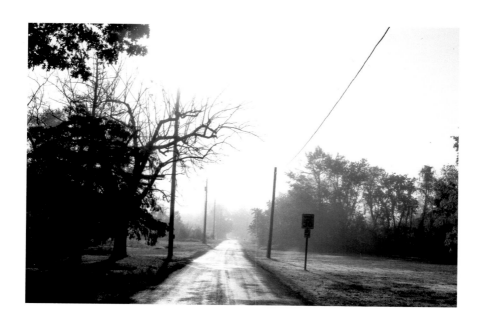

Elliott Island Marsh, Route 331,
Dorchester County

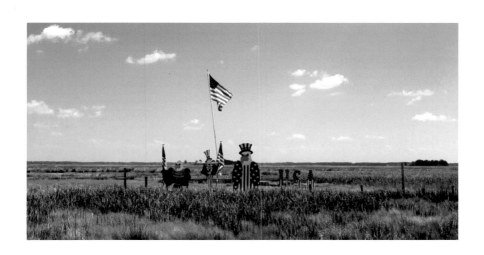

Blackwater National Wildlife Refuge,
Route 16, Dorchester County

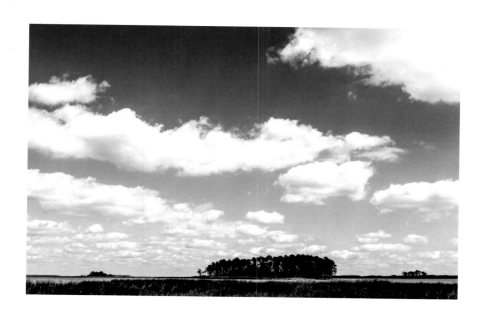

Mason Dixon Marker, Route 454, Marydel,
Kent County, Delaware

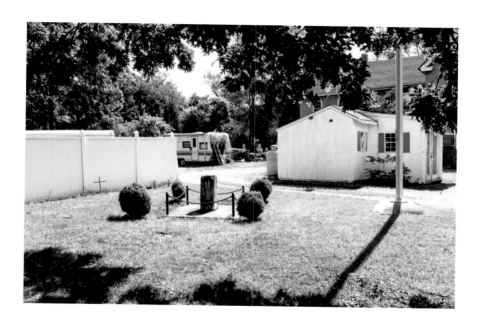

Mason Dixon Line, Route 54,
Mardela, Wicomico County

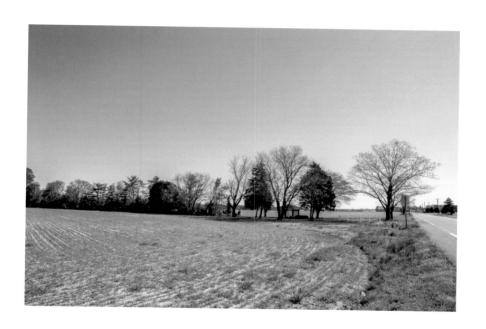

Pocomoke River, Route 12,
Snow Hill, Worcester County

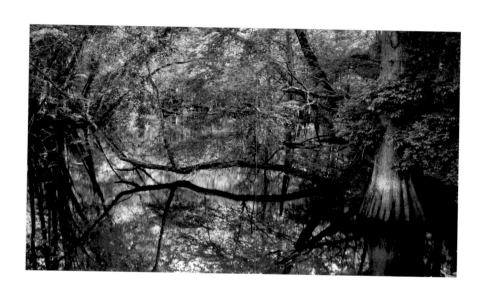

Fishing Pier, Ocean City,
Worcester County

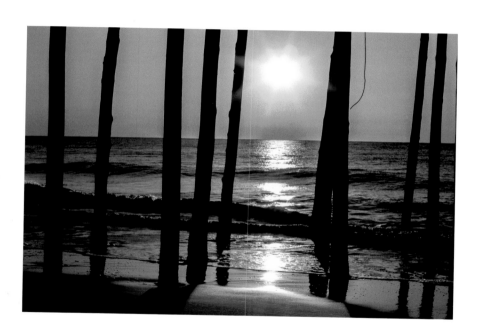

Beach, Ocean City,
Worcester County

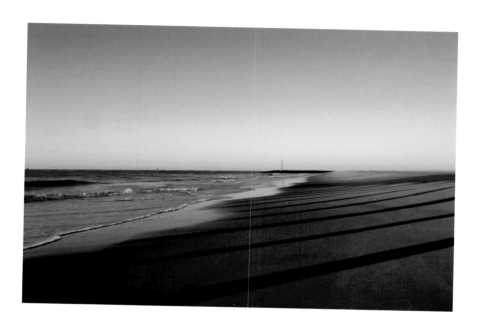

Hemlock Forest, Swallow Falls State Park,
Route 219, near Oakland, Garrett County

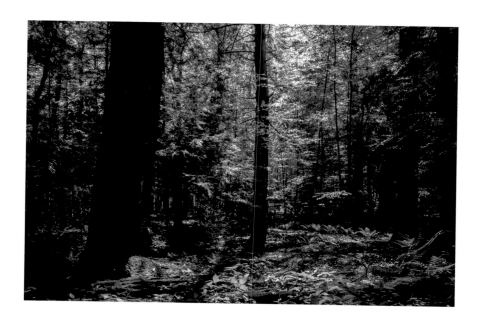

Hemlock Forest, Route 219, near Oakland,
Garrett County

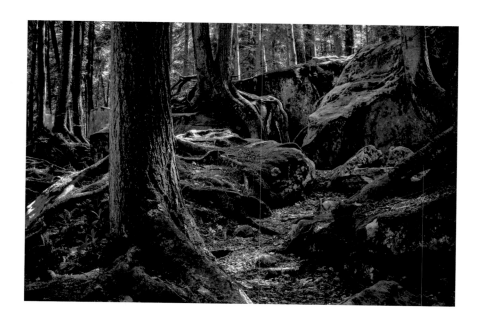

Muddy Creek Falls, Route 219, near Oakland,
Garrett County

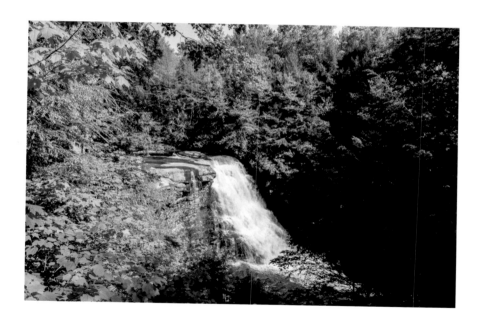

Lizard, Route 404,
Caroline County

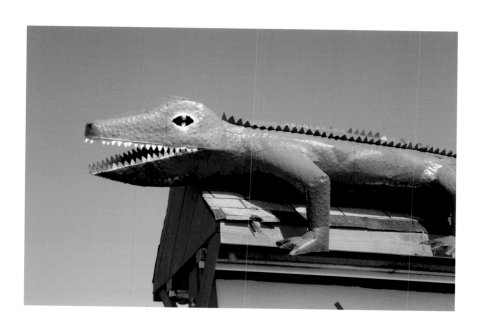

Fields, Route 70, Exit 18, Clear Spring,
Washington County

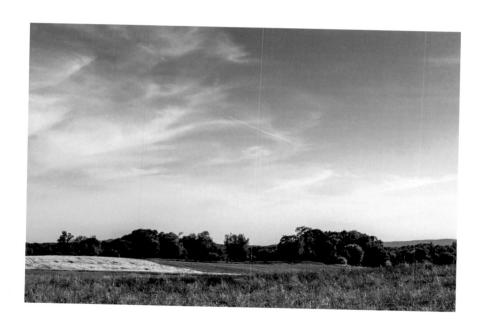

Windmills, Route 13, Deer Park,
Garrett County

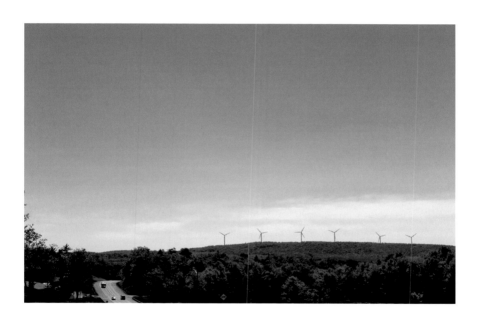

Curve Warning, Route 36, Luke,
Allegheny County

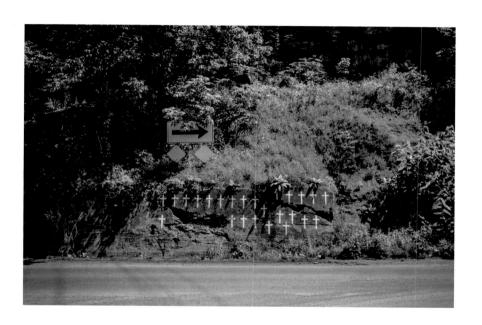

Potomac River, Route 70, Exit 12, Big Pool,
Washington County

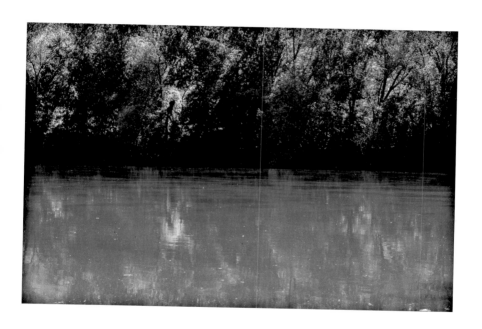

Great Falls, Potomac,
Montgomery County

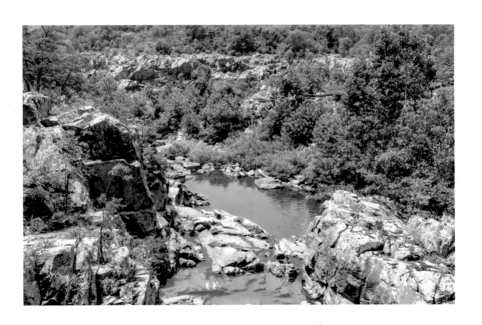

Gilpins Falls Covered Bridge, Route 272,
Northeast, Cecil County

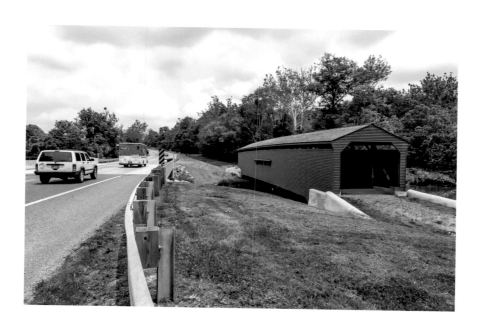

Bird Houses, Route 336, Wingate,
Dorchester County

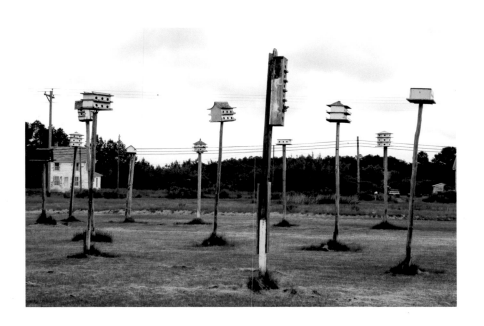

Flint Furnace, Susquehanna State Park,
Darlington, Harford County

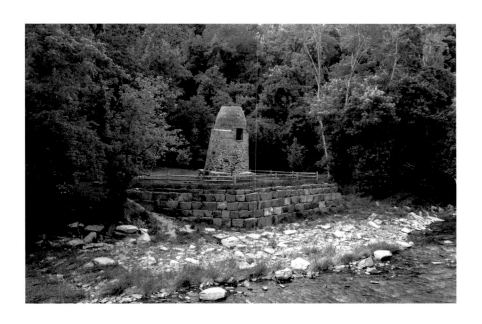

"CAP'N BOB'S CRABS," Havre de Grace,
Cecil County

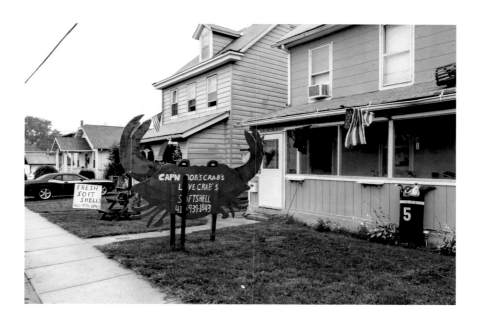

Gas Dock, Route 4, Lusby,
Calvert County

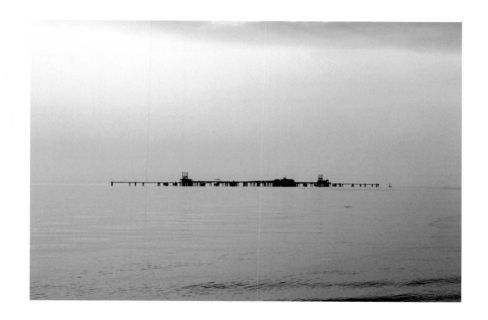

Calvert Cliffs State Park, Route 4,
Lusby, Calvert County

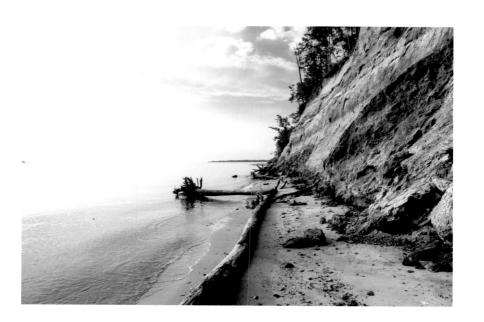

Grey's Creek Beaver Dam, Route 4,
Lusby, Calvert County

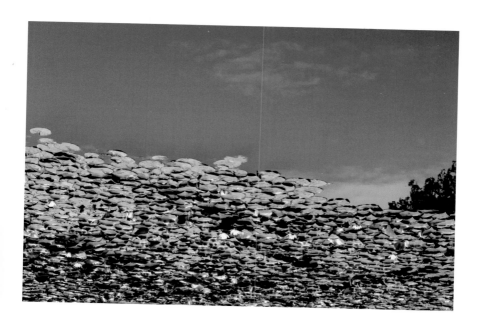

Grasses, Patuxent Research Refuge, Baltimore
Washington Parkway and Powder Mill Road,
Laurel, Anne Arundel County

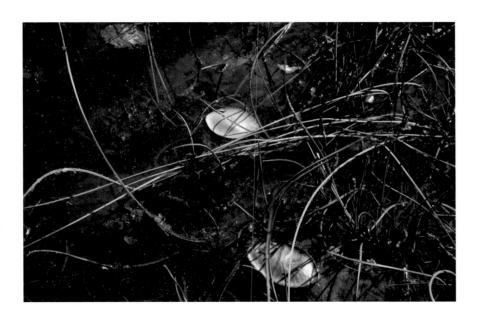

Gray's Creek Beaver Dam Meadow,
Route 4, Lusby, Calvert County

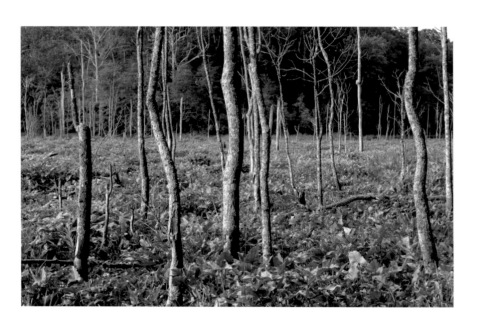

Battle Creek Cypress Swamp, Route 508 and
Grey's Road, Bowens, Calvert County

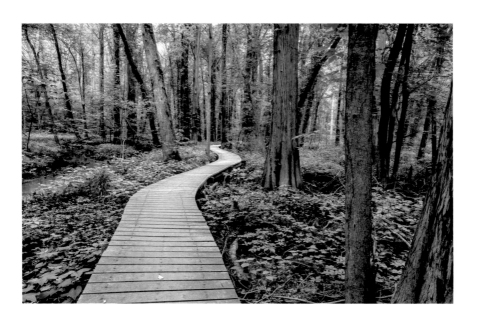

Gunpowder River, Route 1,
Kingsville, Baltimore County

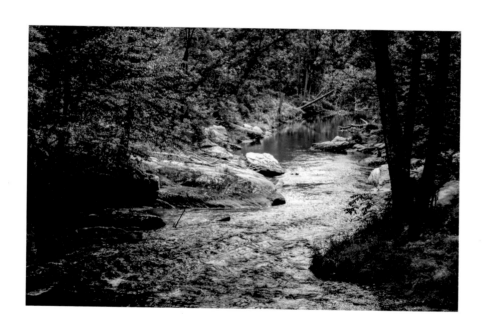

Wicomico River, Routes 301 and 234,;
Chaptico, St. Mary's County

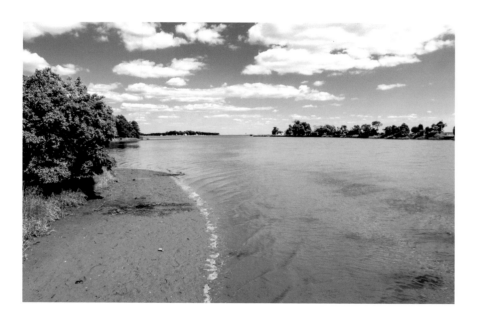

Allen's Fresh Run, Routes 301 and 234,
Newport, Charles County

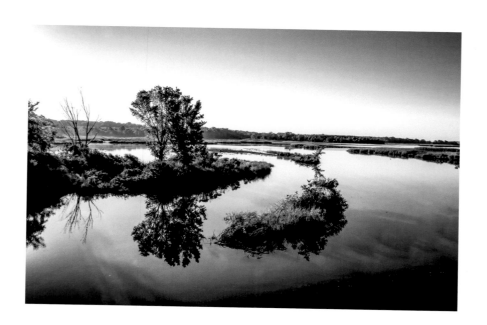

St. Clements Island, Route 242, Coltons Point, St. Mary's County

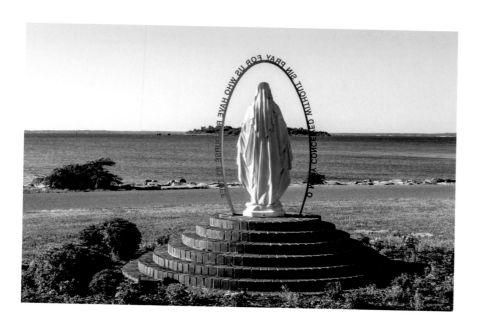

Crab Pot Floats, Route 249,
Piney Point, St. Mary's County

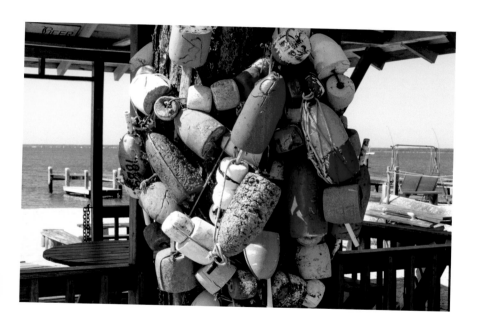

Crab Pot Floats, Ewell, Smith Island
Somerset County

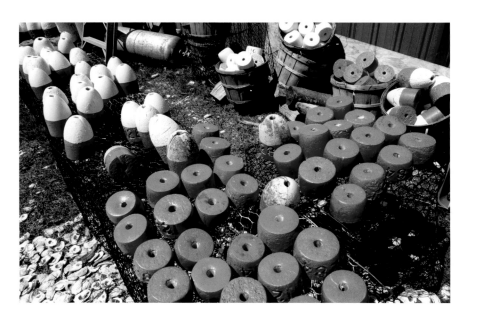

Anacostia River, Route 1, Bladensburg,
Prince Georges County

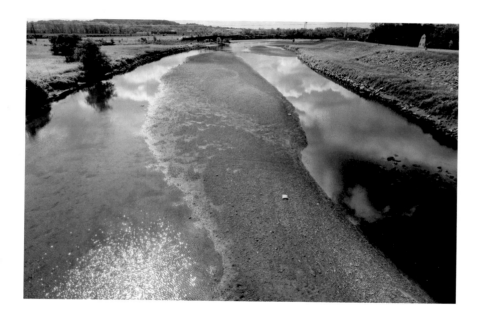

Stack, Sparrows Point Road, Sparrows Point,
Baltimore County

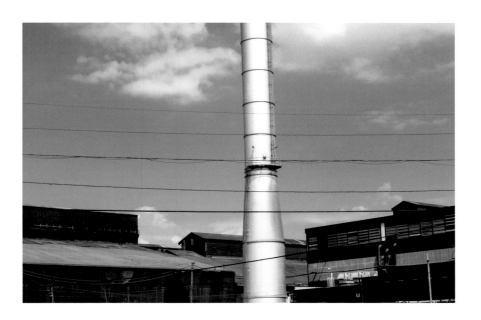

Baltimore Skyline,
Baltimore City

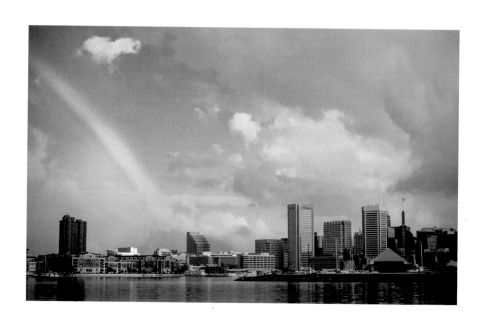

Ewell, Smith Island,
Somerset County

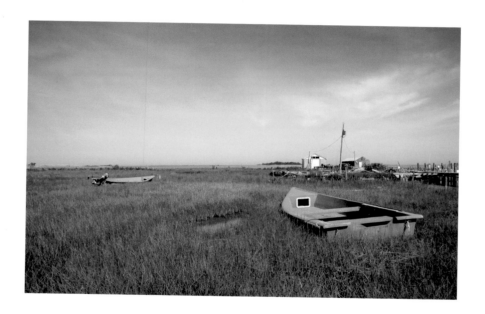

Potomac River, Route 340, Knoxville,
Frederick County

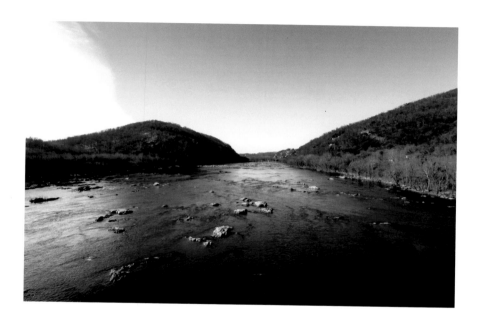

Route 363, Dames Quarter,
Somerset County

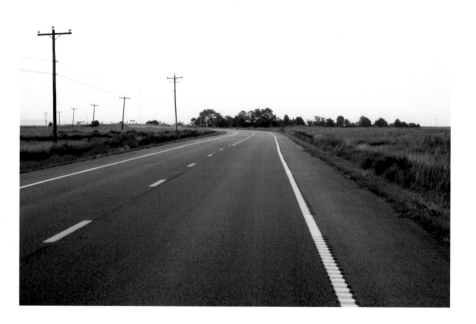

Ewell, Smith Island,
Somerset County

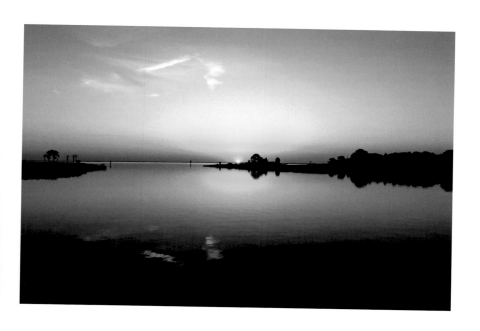

Other Schiffer Books on Related Subjects:

Copyright © 2014 by Kenneth Basile

Library of Congress Control Number: 2014947165

Designed by Molly Shields
Type set in Hightower/Book Antiqua

ISBN: 978-0-7643-4721-4
Printed in China

Published by Schiffer Publishing, Ltd. • 4880 Lower Valley Road • Atglen, PA 19310
Phone: (610) 593-1777; Fax: (610) 593-2002 • E-mail: Info@schifferbooks.com

For the largest selection of fine reference books on this and related subjects, please visit our website at
www.schifferbooks.com.
You may also write for a free catalog.

This book may be purchased from the publisher.
Please try your bookstore first.

We are always looking for people to write books on new and related subjects. If you have an idea for a book, please contact us at
proposals@schifferbooks.com